ABERGAVENNY

HISTORY TOUR

ACKNOWLEDGEMENTS

Thanks to Rachael Rogers at Abergavenny Museum and museum staff for use of the photographs in the archives; Frank Olding and the late Gwyn Jones for their knowledge of local history; Abergavenny Local History Society, and the society's 1980s Street Survey, recently updated and put online; Canon Mark Soady and his team at St Mary's Priory Church; the Abergavenny and District Tourist Association; Monmouthshire County Council; Office Services' Enterprises; The Barber Shop, Frogmore Street; and everyone who has supplied photographs, advice or help.

First published 2018

Amberley Publishing
The Hill, Stroud,
Gloucestershire, GL5 4EP
www.amberley-books.com

Copyright © Irena Morgan, 2018
Map contains Ordnance Survey data
© Crown copyright and database right
[2018]

The right of Irena Morgan to be
identified as the Author of this work has
been asserted in accordance with the
Copyrights, Designs and Patents Act 1988.

ISBN 978 1 4456 7115 4 (print)
ISBN 978 1 4456 7116 1 (ebook)

British Library Cataloguing in
Publication Data.
A catalogue record for this book is
available from the British Library.

Origination by Amberley Publishing.
Printed in Great Britain.

INTRODUCTION

Traditionally known as the Gate of Wales, Abergavenny (Y Fenni in Welsh) is a lively and historic market town in the scenic Usk Valley on the edge of the Brecon Beacons National Park, and near the Blaenavon World Heritage Site.

Abergavenny's strategic border location has meant it has seen turbulent times. The Romans built a fort named Gobannium. The Normans arrived in the eleventh century and founded a walled town, which grew into what we know today, but only traces of that wall now remain.

Abergavenny is a hub for tourists and sporting activities such as walking, cycling, paragliding, canal boating and pony-trekking. Cycling festivals have become increasingly popular. Major attractions also include the Rotary Club's two-day Steam Rally on the May bank holiday and the Shire Horse Show in July, and there are other thriving festivals for music and art.

The town has won acclaim as a food destination. Award-winning restaurants abound, and each September 30,000 visitors descend over the food festival weekend eager to watch top chefs, hear debates about food production, and sample some of the delicious fare on sale from the 200 specialist stalls staged in landmark venues and in the streets, yards and lanes. A smaller one-day winter food fair is held in December.

In 2016, the National Eisteddfod, the premier cultural event in Wales, made a welcome return with an attendance of 140,000 between 29 July and 6 August. It was last held here in 1913.

Turn a corner in the town centre and you're likely to glimpse a breathtaking view of the surrounding hills or see a ceramic or a blue plaque capturing the spirit of bygone days. This book aims to guide you through some of those historic highlights.

If you would like to find out more, visit Abergavenny Museum set in the ruined Norman castle dating back to 1087.

Author's royalties from this book will go to the museum.

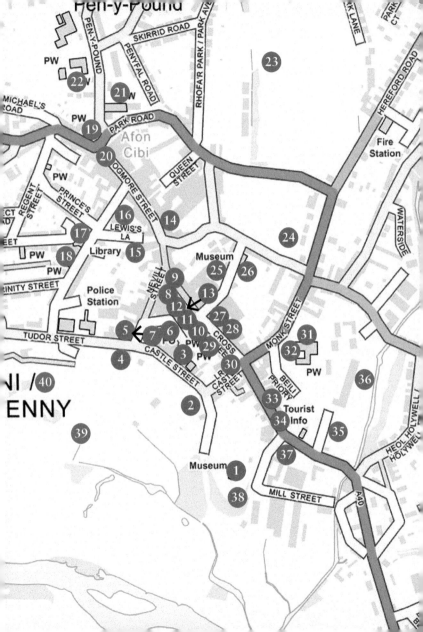

KEY

1. Abergavenny Castle
2. Castle Street
3. Castle Street Churches, Halls and Schoolrooms
4. West Gate
5. Tudor Street Slum Clearance
6. St John's Square
7. The Kings Arms
8. Vaughans of Tretower
9. Former British Legion Club
10. Flannel Street
11. St John's
12. St John's Street Murals
13. The Millennium Mural
14. Cibi Walk
15. Lewis's Lane Foundry
16. Drill Hall
17. Abergavenny Library
18. Holy Trinity Church
19. Abergavenny Baptist Church
20. War Memorial
21. King Henry VIII Grammar School
22. Roman Catholic Church of Our Lady and Saint Michael
23. Bailey Park
24. Former Livestock Market
25. Market Street
26. Bethany Chapel
27. Town Hall
28. Abergavenny Market
29. High Cross
30. The Angel Hotel
31. St Mary's Priory Church
32. Tithe Barn
33. Coach & Horses
34. Gunter Mansion
35. Bus Station
36. Swan Meadows
37. Tan House
38. The Laurie Jones Community Orchard
39. Castle Meadows
40. Linda Vista Gardens

1. ABERGAVENNY CASTLE

Abergavenny Castle is now a welcoming place and a wonderful setting for plays and concerts. Each September it is one of the main venues for the Food Festival (pictured below) and has an interesting town museum. Yet it was once described as being 'oftener stained with the infamy of treachery than any other castle in Wales'. One of the darkest deeds was the 1175 Christmas Day Massacre when a Norman lord slaughtered local Welsh leaders in an act of vengeance.

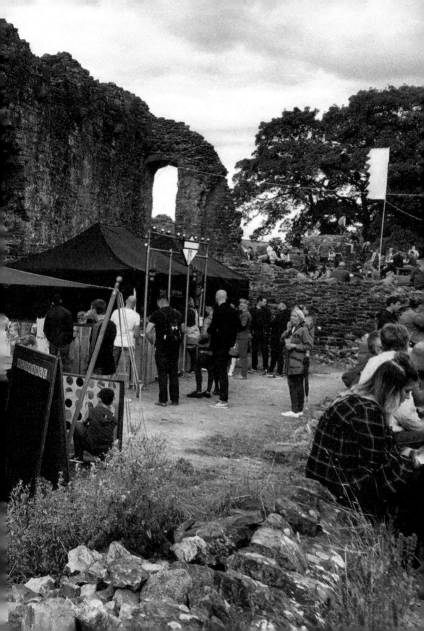

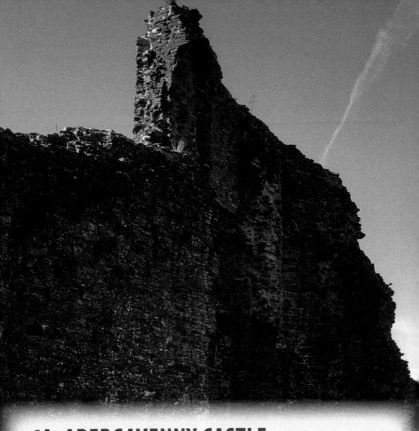

1A. ABERGAVENNY CASTLE

The Norman lord Hamelin de Ballon founded the first motte-and-bailey castle in wood around AD 1087. Abergavenny Castle was destroyed in 1233, so what you can see dates back to the thirteenth century when it, along with the town walls, was rebuilt in stone. The castle was slighted – made uninhabitable – around 1645 during the Civil War. The barbican gatehouse (inset) was strengthened around 1404 at the time of attacks by the Welsh leader Owain Glyndwr.

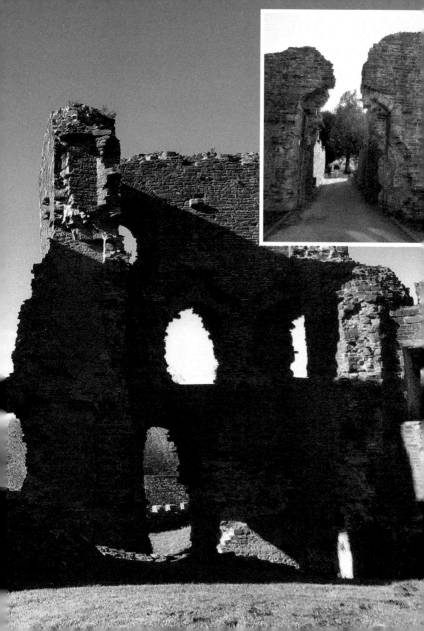

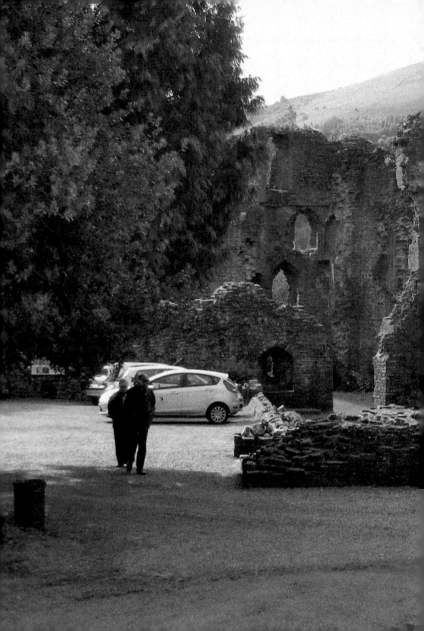

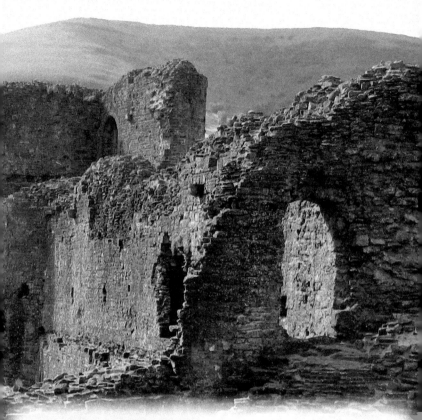

1B. THE GREAT HALL

The first Great Hall at Abergavenny Castle was made of timber. In 1175, the Norman lord, William de Braose, slaughtered Seisyll ap Dyfnwal and other Welsh chiefs there at a Christmas feast. The Welsh had been asked to lay down their arms, as was the custom. Braose's men then rode out to Seisyll's home at Castell Arnallt and killed his young son. The Welsh took revenge in 1182 when they attacked and burned the castle.

1C. ABERGAVENNY MUSEUM

Abergavenny Museum was founded in 1959 in the restored castle 'keep' built around 1819 on the original motte as a hunting lodge for the Marquess of Abergavenny. It holds award-winning exhibitions and hosts family activities. On show are a Victorian Welsh farmhouse kitchen, an air-raid shelter, a saddler's workshop and the interior of the Basil Jones grocery shop from Cross Street. Outside, look out for the willow sculptures, the Victorian garden and the 'bee-friendly' planting.

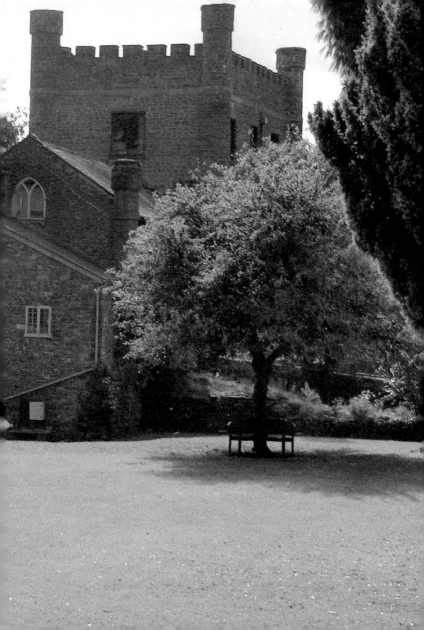

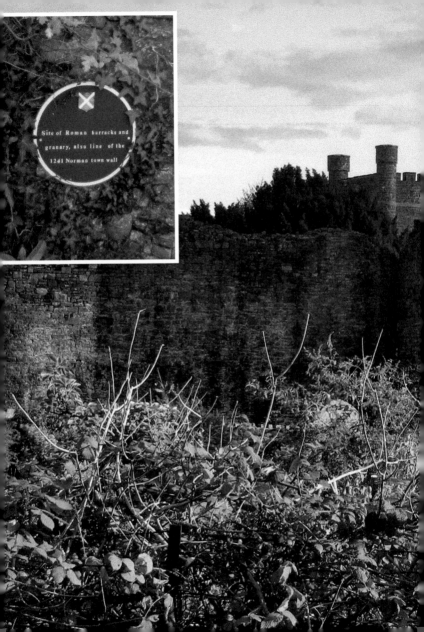

Site of Roman barracks and granary, also line of the 1241 Norman town wall

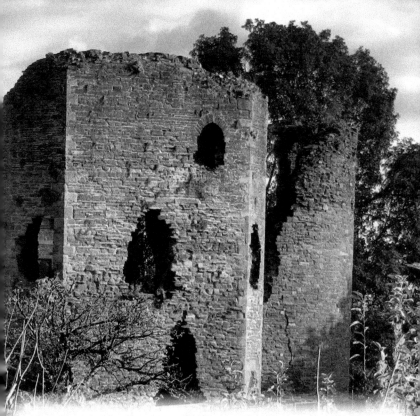

2. THE CASTLE FROM CASTLE STREET

View from Castle Street car park. The strategic position over the River Usk shows why the Normans and – 1,000 years before them – the Romans chose almost the same spot on the long, low hill to build their strongholds. The river's course has changed and would then have been closer. On the far wall of the car park opposite the entrance is a blue plaque showing the line of the 1241 town wall and the Roman fort.

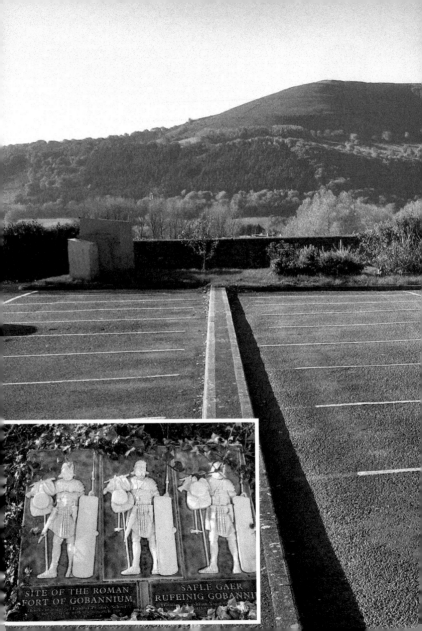

SITE OF THE ROMAN
FORT OF GOBANNIUM

SAFLE GAER
RUFEINIG GOBANNI

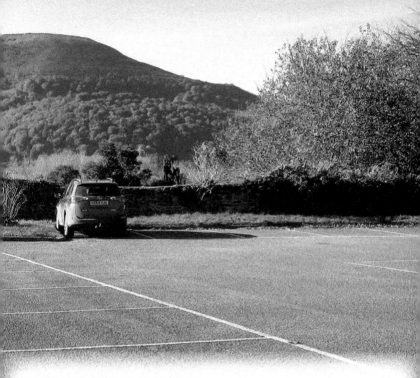

2A. CASTLE STREET

Today, it's a car park with lovely views (the Blorenge Hill), but nearly 2,000 years ago a Roman fort called Gobannium was built here. In Norman times, it was where the town first expanded from the castle (blue plaque near pay point). In 1825, part was a sheep market. A blue plaque, on outside of the public conveniences near Shopmobility, says Town Commissioners bought the land in 1825 for the market, which lasted until 1863. *Inset*: a Roman plaque.

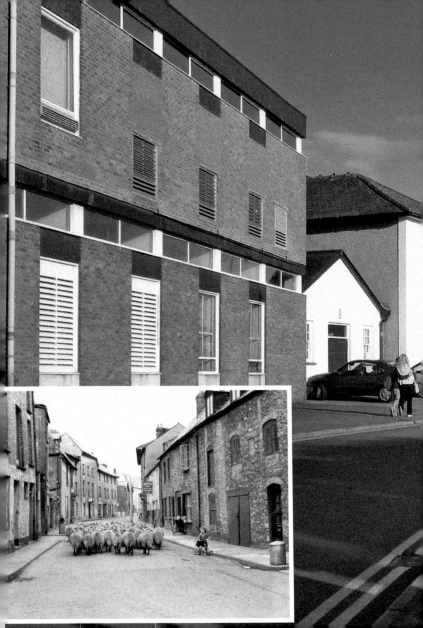

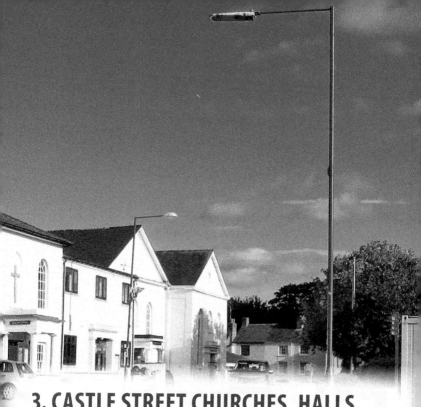

3. CASTLE STREET CHURCHES, HALLS AND SCHOOLROOMS

Ancient and modern. On the right is the former Congregational Church and Schoolroom. The church was founded in 1690, moved to Castle Street in 1707, was rebuilt in 1792 and remodelled in 1839; now it's the United Reformed Church and the schoolroom is occupied by businesses. Then comes the Gateway Church's Rehoboth Centre. The smaller white building is the church hall, adjacent to the Methodist Church, dated 1829. Left is the Royal Mail delivery office. *Inset*: a view of Castle Street from the 1950s.

4. WEST GATE

West Gate, or Tudor Gate, marked by plaques, was one of the main gates in the town wall. It was named after Jasper Tudor, who was at one time Lord of Abergavenny and the great uncle of Henry VIII. Cattle were driven through here in medieval times to market – and for safety during times of Welsh raids. In 1656 Tudor Street was called Potider Streete, an English corruption of the Welsh name Porth Tudur (Tudor's Gate).

5. TUDOR STREET SLUM CLEARANCE

Behind the Kings Arms is a wall with remnants of fireplaces and chimneys from houses in Tudor Street demolished in the 'slum clearance' programmes between 1957 and 1968. The 'slums' proved to be much older than their façades suggested and many townspeople thought they should have been restored. Early seventeenth-century wall paintings were found and features such as fireplaces, doors, oak panelling and windows were salvaged and taken to the museum, but much was destroyed.

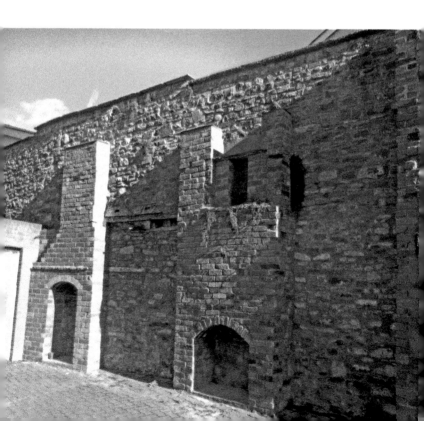

6. ST JOHN'S SQUARE

St John's Square was transformed in 2016 as part of a £1-million facelift for the town centre to make it into a 'pedestrian-friendly open space designed to host various events'. In medieval times, the area around St John's Church was the marketplace, reflected in the old street and pub names. Nevill Street used to be called Rother (type of cattle) and before that Cow Street. *Inset*: St John's Square during the 1950s and '60s demolition.

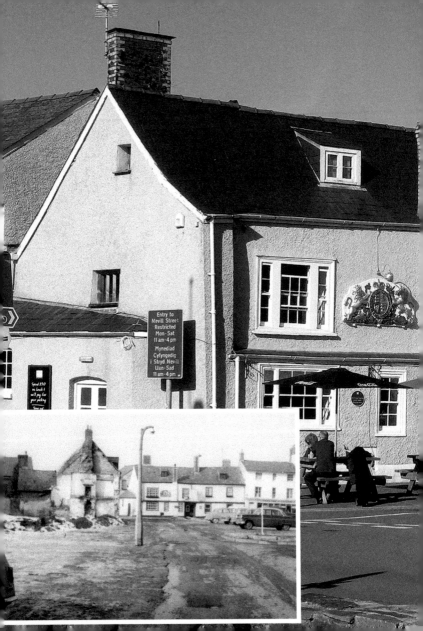

Entry to
Nevill Street
Restricted
Mon-Sat
11 am-4 pm

Mynediad
Cyfyngedig
i Stryd Nevill
Llun-Sad
11 am-4 pm

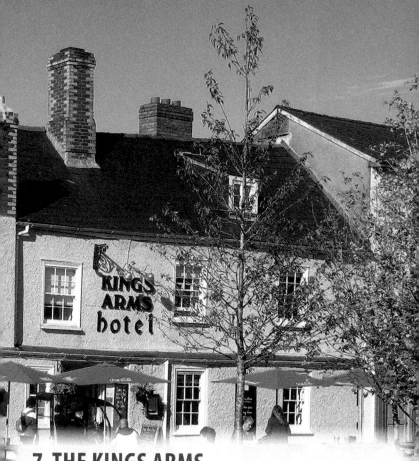

7. THE KINGS ARMS

The Kings Arms is one of the town's oldest inns and dates back to the sixteenth or seventeenth century. At the front of the inn is a royal coat of arms thought to have been put up in Victorian times. In one bar is an inscription written by soldiers billeted there during the Napoleonic Wars: 'Good quartering forever 1817. King & 15th Huzzars Hall Troop 24.' *Inset*: the Kings Arms in the clearances.

8. VAUGHANS OF TRETOWER

Now the Trading Post tearooms, this was built in 1600 as a town house for the Vaughans of Tretower. The chevron with children's heads is the family crest. The cows' heads were probably added when it was the Cow Inn between the 1780s and 1860s, or a temperance bar. An altar stone from the former St John's Church was discovered in the chimney and presented to Holy Trinity Church. *Inset*: the Charles Price shop next to the former British Legion.

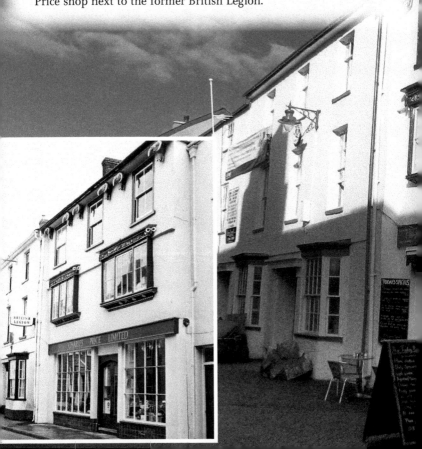

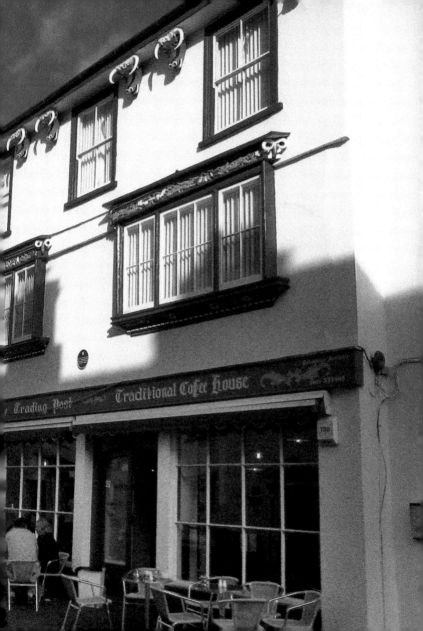

9. FORMER BRITISH LEGION CLUB

The former British Legion Club in Nevill Street has been redeveloped into the Gurkha Corner restaurant (No. 10) and the Coffee Pot (No. 12), the site where hair bleacher James Jones lived in 1741. The plaques illustrate that Abergavenny was known for the manufacture of white periwigs made of goat hair, sometimes fetching up to 40 guineas each. A method of wig bleaching was said to have been invented in the town. *Inset*: the ceramic and blue plaque.

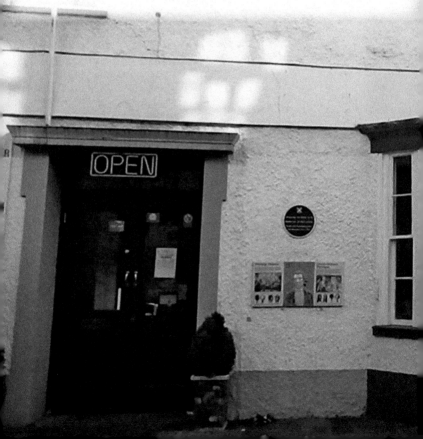

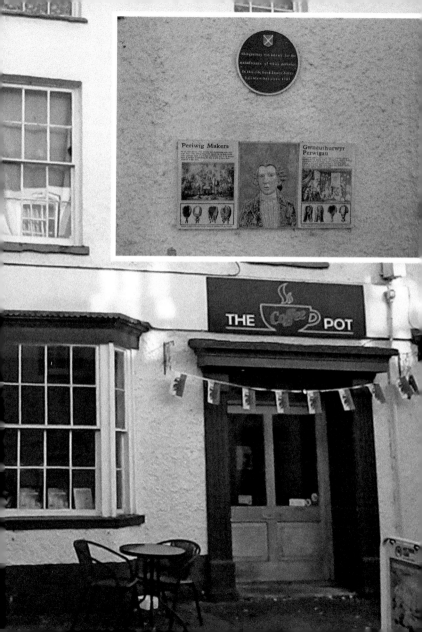

10. FLANNEL STREET

The remains of an eighteenth-century loom were found in the roof of the adjoining building during alterations. The quality of Abergavenny flannel was particularly fine and soft. Flannel was also brought into the town from the countryside to be sold at market. Previously, Flannel Street was known as Butchers' Row and was part of the medieval market, joining up with Chicken Street where poultry was sold.

Flannel Street

Abergavenny was known for its flannel, a fine soft woollen cloth.
Here was the site of a flannel mill in the 18th century.

Thanks to the pupils of Llanvihangel Crucorney Primary School for assisting with the research
Ceramic by Ned Heywood

Stryd y Wlanen

Roedd y Fenni'n enwog am ei gwlanen, brethyn gwlân meddal a
main. Dyma le roedd melin wlanen yn sefyll yn y 18fed ganrif.

Diolch i ddisgyblion Ysgol Gynradd Llanfihangel Crucornau am gynorthwyo gyda'r ymchwil.

11. ST JOHN'S

St John's was the original Norman parish church and became the King Henry VIII Grammar School in 1542, supported by tithes gained after the dissolution of St Mary's Priory, which then became the parish church. One punishment for pupils was to be hoisted up for some hours in a wicker basket. A new grammar school was built in Pen y Pound in 1898, and St John's became a Freemasons' lodge.

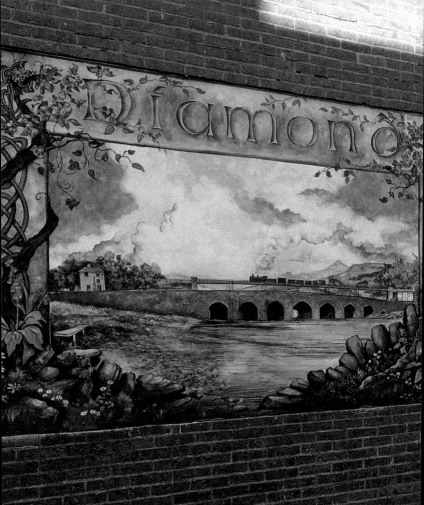

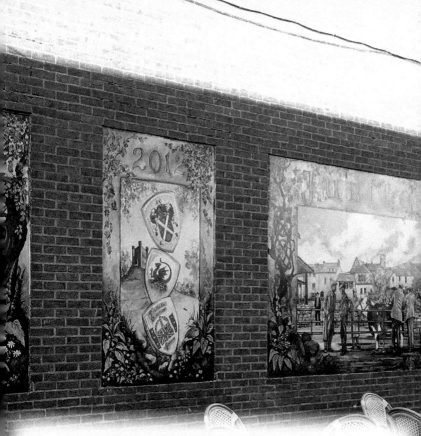

12. ST JOHN'S STREET MURALS

As part of the Queen's Diamond Jubilee in 2012, Abergavenny Town Council unveiled a set of murals in St John's Street. Local artist Dave Parkinson was commissioned to paint three murals that captured the history of the town. There is a one of the cattle market, the former railway bridge at Llanfoist, and a painting featuring the three shields of the town's coat of arms, the Welsh flag and the Diamond Jubilee emblem.

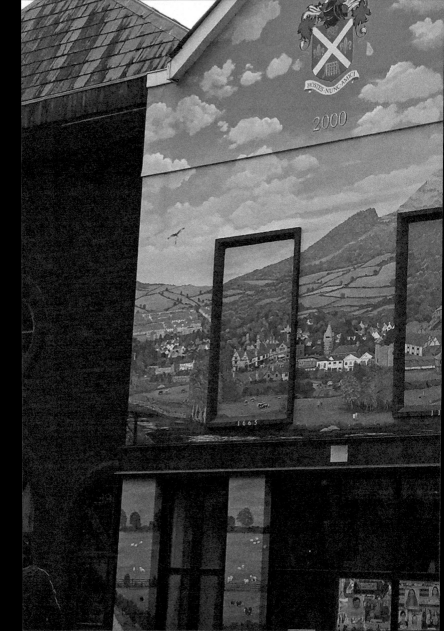

HOSTES·NUNC·AMICI

2000

1665

13. THE MILLENNIUM MURAL

The *Millennium Mural,* painted by artist Frances Baines, has four windows into the past showing how the town would have looked in the years 1100, 1665, 1856 and 1936. In the background is a representation of the Skirrid Mountain and at the top is the Abergavenny coat of arms. It was funded by Abergavenny Town and Monmouthshire county councils.

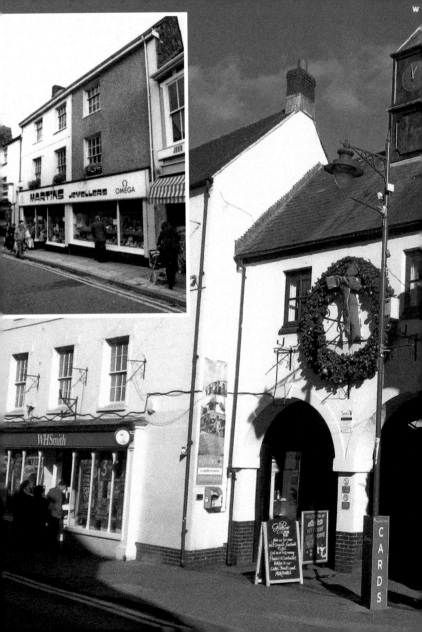

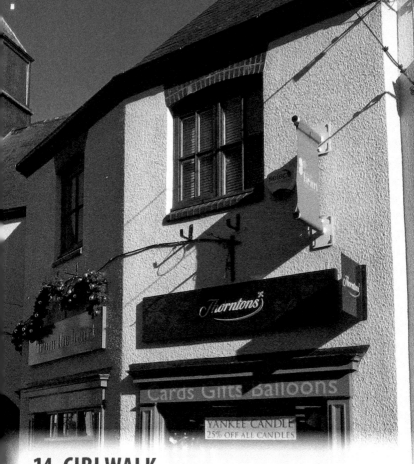

14. CIBI WALK

The entrance to the Cibi Walk shopping precinct in Frogmore Street, which has a statute of a shepherd at its centre. *Inset*: Frogmore Street as it looked before the Cibi Walk was built. The precinct and its entrance were constructed after part of the Martin's building was demolished, and was officially opened in 1989.

15. LEWIS' LANE

John Lewis bought the Lamb pub around 1803, converted it into an ironmonger's foundry and gave his name to Lewis' Lane. The History Society's street survey said the Lewis' Lane foundry made the iron railing for Hyde Park in London for politician Benjamin Hall MP (later Lord Llanover), president of the Board of Health and first Commissioner of Works. It is said the same mould was used for the gates at St Mary's Priory Church. Lewis' foundry is now long gone.

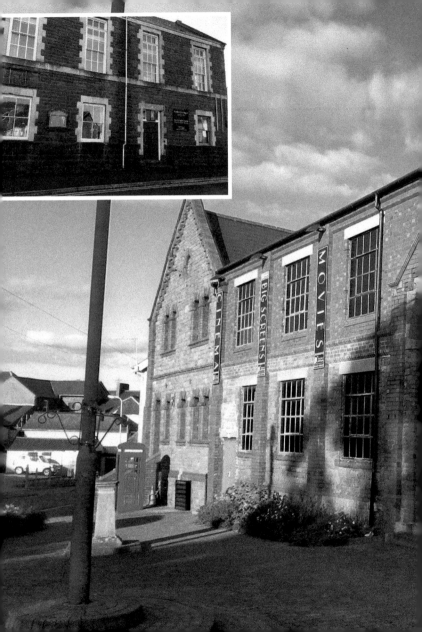

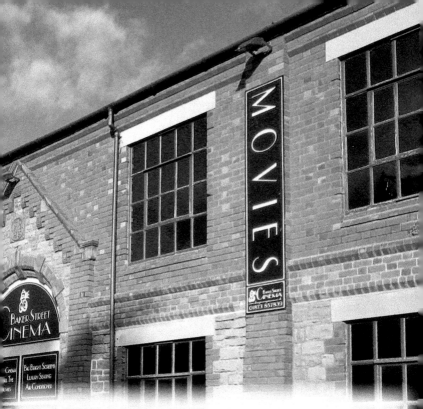

16. DRILL HALL

Now the Baker Street cinema, the former Drill Hall was built for the Abergavenny detachment of the 4th Volunteer Battalion of the South Wales Borderers (VBSWB) and was opened in 1896. In November 2012, the cinema was the venue for a royal film premiere when Prince Charles came to see the film *Resistance*, based on the novel by Abergavenny author Owen Sheers, who co-wrote the script. *Inset*: opposite the cinema is the former police station, now a separate café and art gallery.

17. ABERGAVENNY LIBRARY

Abergavenny Library is currently housed in Baker Street in a 1906 building funded by the Carnegie Foundation costing £4,000. But there are plans to move it into the Town Hall and market complex. The main entrance is flanked by two carved heads: philanthropist Andrew Carnegie and the Marquess of Abergavenny. Look out for the small garden laid out in 2006 to mark the centenary and the misspelling of Abergavenny in stone with three 'n's (inset).

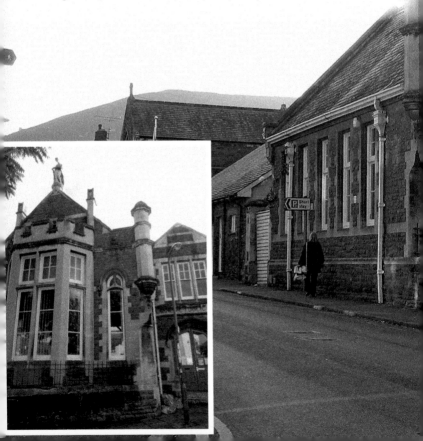

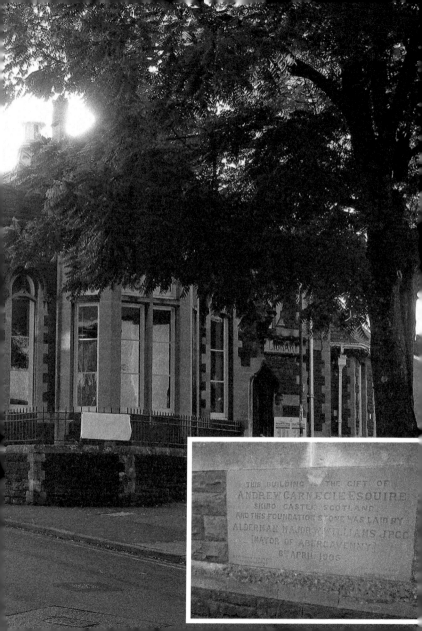

THIS BUILDING IS THE GIFT OF
ANDREW CARNEGIE ESQUIRE
SKIBO CASTLE SCOTLAND
AND THIS FOUNDATION STONE WAS LAID BY
ALDERMAN MAJOR H WILLIAMS JPCC
(MAYOR OF ABERGAVENNY)
6TH APRIL 1905

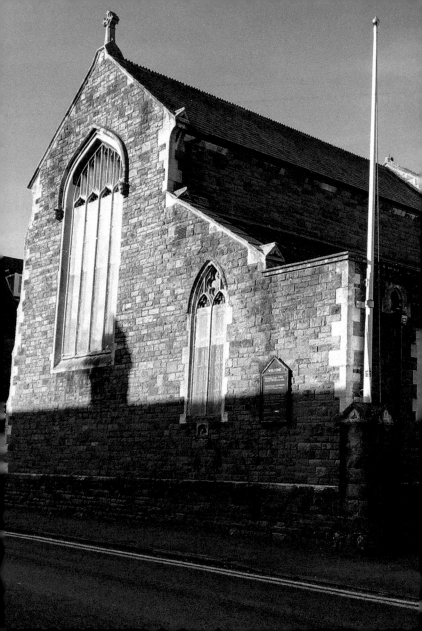

18. HOLY TRINITY CHURCH

Holy Trinity Church, built on the 'Grove Fields' (now known as the Grofield area), was endowed by Miss Rachael Herbert in 1840 and forms part of an early Victorian complex with the Vicarage, almshouses and a church hall, which was formally a girls' school. The altar stone dating back to medieval times is from the original parish church, St John's, and was salvaged from the former Cow Inn in Nevill Street.

19. ABERGAVENNY BAPTIST CHURCH

Abergavenny Baptist Church, built in 1877, dominates one end of Frogmore Street. Tesco's store stands on the site of the previous chapel, which became too small and was used as a church hall; there are still gravestones behind the store. *Inset*: opposite the church at the Barber Shop, No. 37 Frogmore Street, is the birthplace of thriller writer Ethel Lina White, who wrote the books that became the famous films *The Lady Vanishes* and *The Spiral Staircase*.

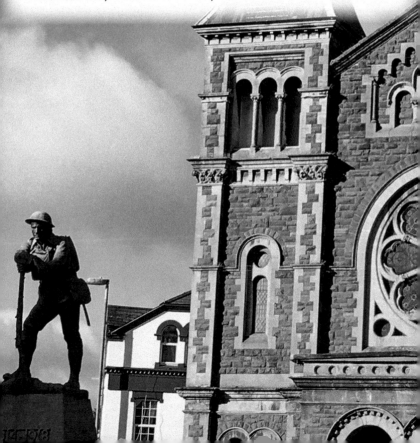

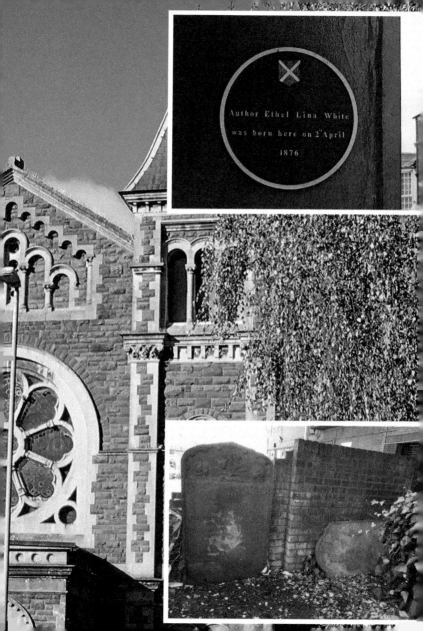

Author Ethel Lina White
was born here on 2 April
1876

20. WAR MEMORIAL

The war memorial by Gilbert Ledward in Frogmore Street, pictured here in the 1950s, stands as a tribute to the 3rd Battalion Monmouthshire Regiment who fell in the First World War. The memorial says, 'This plaque commemorates on the 8th May 1995 the 80th anniversary of 3rd Mons Memorial Day in the 1914–18 war. On that day in 1915 the battalion suffered heavy casualties in the second battle of Ypres.'

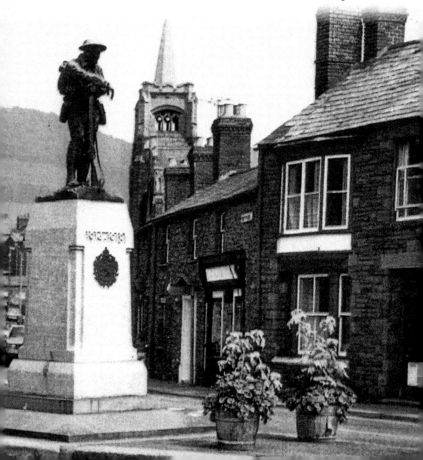

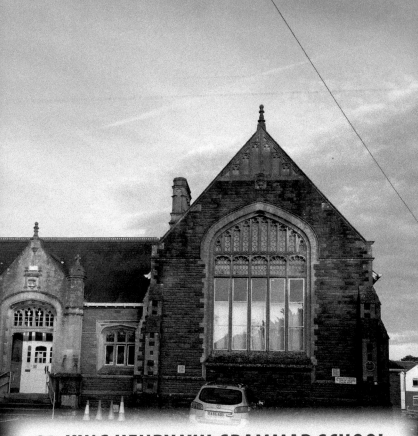

21. KING HENRY VIII GRAMMAR SCHOOL

The former King Henry VIII Grammar School in Pen y Pound is now the Melville Centre and Theatre. Behind it are a dance school and the Greenfingers gardening services. Built in 1898 and designed by E. A. Johnson, the Grade II-listed building had replaced the Grammar School in St John's Street where it had been since its foundation in 1543. The school moved to Old Hereford Road in the 1960s and then became a comprehensive school. Nearby is the historic Presbyterian Church.

22. ROMAN CATHOLIC CHURCH OF OUR LADY AND SAINT MICHAEL

The foundation stone of the Roman Catholic Priory Church of Our Lady and Saint Michael was laid on 19 May 1858. The church and presbytery were designed by Benjamin Bucknall, who had worked for the noted architect Pugin. The crucifix is a 1919 war memorial in memory of Captain Elidyr Herbert of Llanover, and the Abergavenny fallen. The St Michael's Centre for community activities is at the rear of the church. *Inset*: a memorial to St David Lewis.

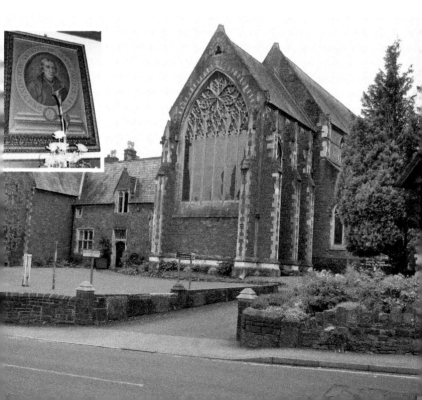

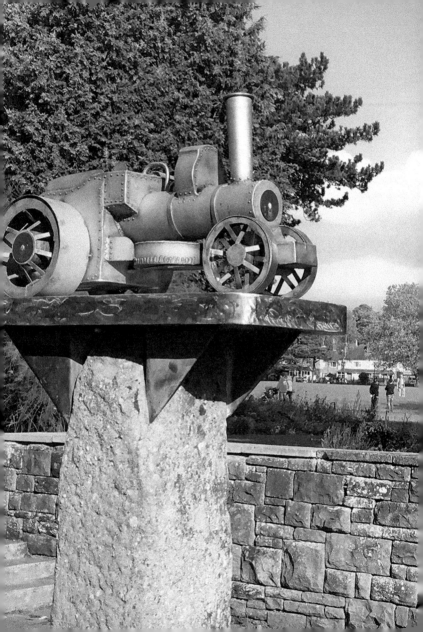

23. BAILEY PARK

Bailey Park is home to Abergavenny RFC and has a bowling green, bandstand, children's play area, and an active friends' group. Each year it hosts popular events such as the Rotary Club's Steam Rally and the Shire Horse Show. Crawshay Bailey II, son of the ironmaster, developed it as a park after leasing the site called Priory Meadows in 1883. It was bought by the town in 1894 for £5,000.

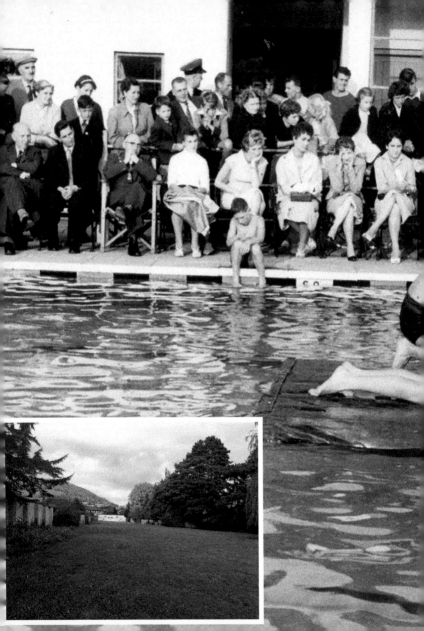

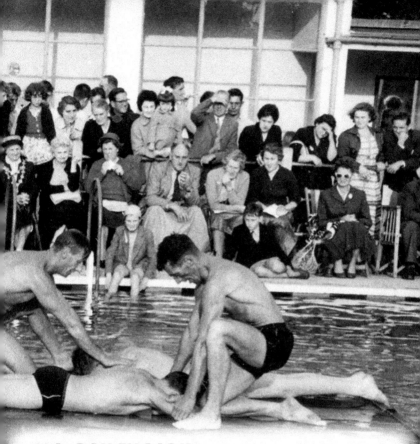

23A. BAILEY PARK

From 1938, Bailey Park had a popular open-air swimming pool and children's pools. Pictured is a well-attended life-saving demonstration. The lido was run by the local authority and then with help from a friends' group but became disused. It was closed in 1996, demolished in 2006 and filled in. In 2017, a group of enthusiasts was formed and a campaign launched to get the lido reopened. *Inset*: the site of the lido, now grassed over.

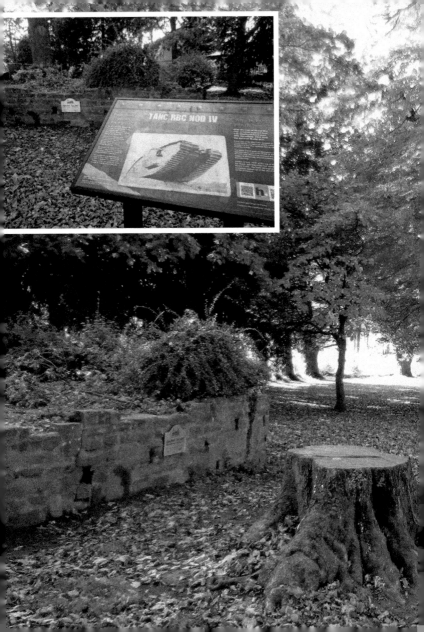

TANC RBC NOO IV

23B. BAILEY PARK

After the First World War, Abergavenny was presented with a Mark IV tank for its exceptional contribution to the war effort. The plinth for the tank still remains in the park and an information board has been set up. In 1919, the mayor and mayoress planted horse chestnuts taken from the Verdun battleground in a 'peace grove'. A Verdun oak was planted at Bryngwyn, near Raglen. *Inset*: the plaque on the plinth.

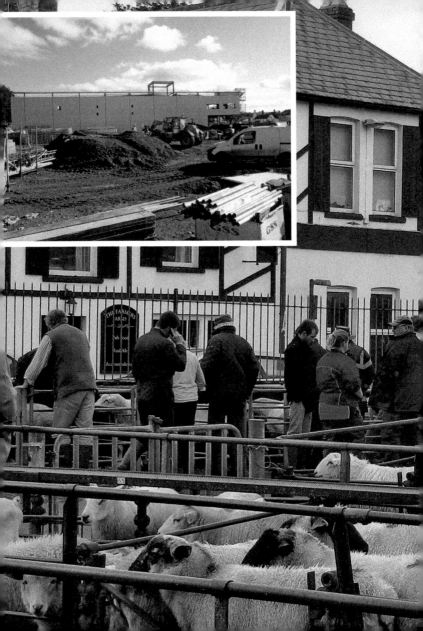

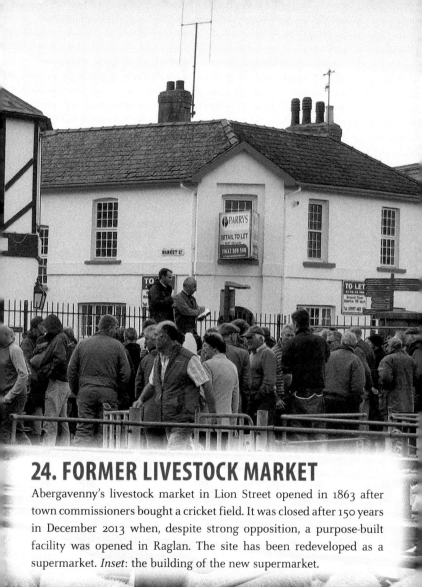

24. FORMER LIVESTOCK MARKET

Abergavenny's livestock market in Lion Street opened in 1863 after town commissioners bought a cricket field. It was closed after 150 years in December 2013 when, despite strong opposition, a purpose-built facility was opened in Raglan. The site has been redeveloped as a supermarket. *Inset*: the building of the new supermarket.

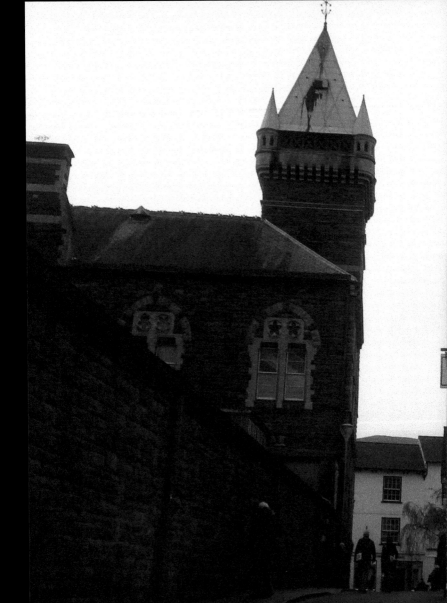

25. MARKET STREET

Market Street has a jettied row of shops with a raised pavement, sixteenth century in origin, remodelled around 1800. This was originally a lane leading to the small postern gate in the medieval town wall to the Cibi Brook. A map names it as 'Traitor's Lane' from the tale of a Welsh sympathiser letting in Owain Glyndwr in 1404, who burned the town. Look at the Town Hall clock, which has a black face on the north side.

26. BETHANY CHAPEL

The former Bethany Chapel, built in 1882, has been restored as a café, concert space and art gallery associated with the Art Shop in Cross Street. *Inset*: the Grade II-listed building, pictured in the background before the demolition of Facey's brewery (hence Brewery Yard), closed as a place of worship in 1990. It was previously a Museum of Childhood and then became a base for the community recycling project Homemakers, which moved to Union Road West.

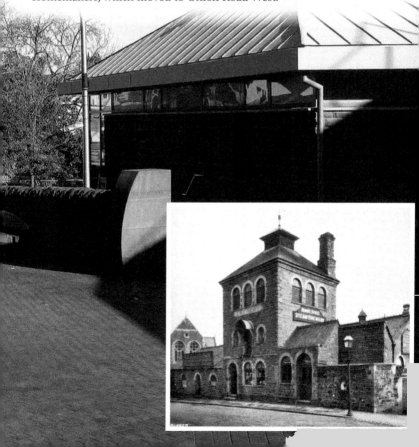

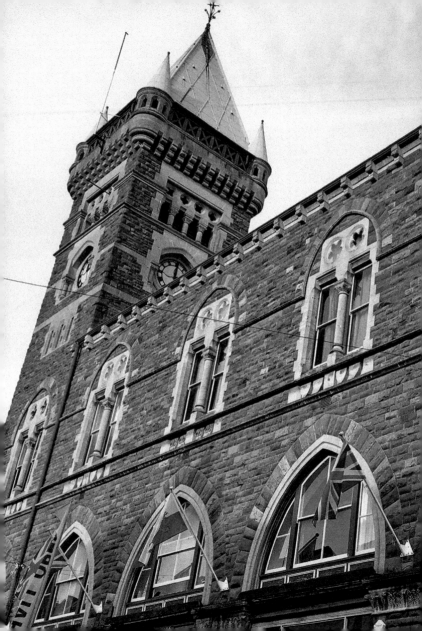

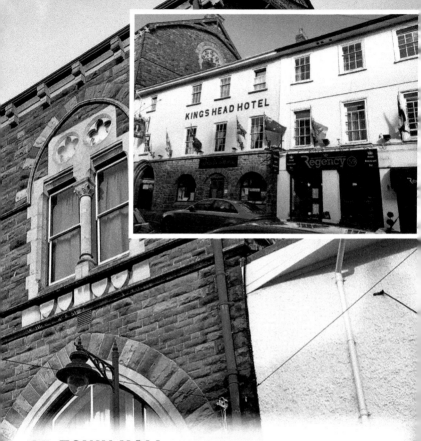

27. TOWN HALL

Abergavenny Town Hall with its distinctive green tower contains offices, a council chamber, and the old corn exchange. There are plans to redevelop it as a community hub with a library. Its 'hidden gem' is the Borough Theatre where The Beatles appeared in 1963. It was built in 1870/71 to replace an earlier courtyard-style market designed by John Nash. Next to it is the historic Kings Head Hotel and restaurant.

28. ABERGAVENNY MARKET

Abergavenny's famous market has been held since medieval times. The main one is held each Tuesday with others on Fridays and Saturdays and a 'flea market' on Wednesdays. Others are the monthly farmers' market; antique, arts and craft fairs; an annual toy fair; and in September the Abergavenny Food Festival. Each year, Arts Alive volunteers create hanging decorations as an art installation. The 2017 theme was chickens – free range, of course.

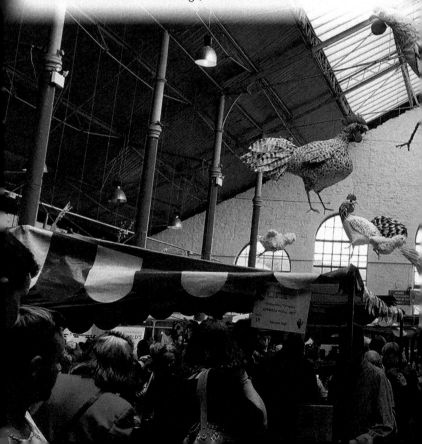

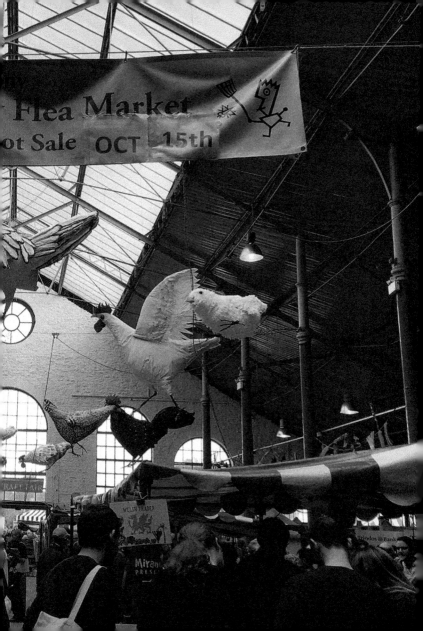

S ARE RECORDED BELOW WHO MADE THE SUPREME SACRIFICE DURING T

BOTT.W	COODE.E	MORGAN.F.L	THOMAS.O	DAVIES.P	PRICE.A	
PEY.G.C	GOUGH.W.F	MORGAN.M	WALSH.V.G	DAVIES.J	PEMBRIDGE.	
KER.R.L	GRIFFITHS.I.V	MORGAN.W.A.H	WALTERS.F	DAVIES.W	PEMBRIDGE.	
LSDON.F.J	GRIFFITHS.P.D	MORRALL.E.P.B	WALTERS.W.C	EASTUP.W.J	POWELL.F	
RKER.R.B	GWENLLAN.E	MORRIS.A.E	WATKINS.C.H	EVANS.B	PRITCHARD.	
ATH.J	GWYTHER.H	MORRIS.D.S	WATKINS.I.H	EVANS.C.G	PRITCHARD.V	
RRY.H.V	GIBBONS.R.C	MADDEN.E	WATKINS.J	EVANS.A.G	PROSSER.	
ST.W.J	GRIFFITHS.T.C	NASH.C	WATKINS.J.W	EVANS.P	PROBERT.	
SWELL.W	HALL.W	NICHOLLS.F.E	WATTS.W.J	GRIFFITHS.R	PAINTER.C	
UGHTON.R.H	HANFORD.G	NORCROVE.E.C	WEAVER.B.G	GIBBONS.A.G	PRICE.V	
WCOTT.C.O	HARDING.J.G.E	NORTON.J.A	WEBB.C.D	GARDNER.E.O	PAULING.	
WCOTT.A.D	HERBERT.J.H	NEIL.S	WEEKS.E	GRIFFITHS.A	PROSSER.I	
WDEN.H.J.G	HEYWOOD.C.C	NASH.T	WELSH.W	HERBERT.E.J.B	QUINTON.G	
WEN.J.T	HILL.W.D	O'GRADY.W	WELSH.W	HARRY.D	REA.W.H	
EAKWELL.D	HOLLAND.A.D	PAVORD.J.A	WHITE.A.I	HOLMES.E	RADCLIFFE.	
EAKWELL.N	HOWELL.F.P	PHILLIPS.J.W	WHITEHEAD.C.H.T	HALLET.S	ROWBERRY.	
OWN.W.C.J	HANBURY.E.E	PICKERING.T.H	WHITEHOUSE.T.A	HOLMES.M.W	SAUNDERS.	
UTON.J	HIGGS.C.T.S	PIERCE.E.F	WILLIAMS.A.V	HARRIS.E	SULLIVAN.I	
RCHER.H	IBALL.I.J	PITT.H.H	WILLIAMS.C	HOBBS.C.H.G	SMITH.T.G	
SHER.D.J.B	JACKSON.J.S	POWELL.D.W	WILLIAMS.C	JONES.D.B	SOLLARS.	
LEY.C	JAMES.W	POWELL.W	WILLIAMS.H	JACOB.C.H	SHEEN.R.	
NOLLY.J.L	JAMIESON.W.J.C	PRICE.A	WILLIAMS.M	JACOB.I	STEEN.C.	
RR.L.H	JENNINGS.F.G	PRICE.A	WILLIAMS.W	JONES.J	SAYCE.J	
PENTER.S	JONES.H	PROSSER.P	WILSON.W.W	JONES.T	STEWART.A	
MBEY.W	JONES.J.G	PROSSER.E	WINNEY.R.V	JONES.E.V	THOMAS.J	
KE.W.T	JONES.N	PHILLIPS.F.J.H	WINTER.E.H	JONES.G	TEAGUE.A	
PER.L.G	JONES.R.F	RALPH.J	WOODWARD.H.J	JONES.A.E	TAYLOR.J	
BETT.A.E	JONES.T.R	RAWLINS.R.D	WORKMAN.A.E	JONES.A.M	TAYLOR.H	
EY.C	JONES.W	REES.W.M	WYATT.W.J	JONES.J	THOMAS.W.I	
OOK.C.H	JONES.W.E	REGAN.J	WHATMORE.C.A	JONES.B	TYLER.C.H	
NOLLY.T	JONES.B.L	REYNOLDS.E.J	WIGLEY.W.H	JENKINS.A	WILLIAMS.T.W	
NOLLY.J.C	JONES.G	ROACH.F	WALKER.A	JONES.J	WILLIAMS.F	
NOLLY.W	JORDAN.T.C	ROACH.H	ADAMS.J.H	JONES.W	WILLIAMS.R	
NEGY.R.L	KNIGHT.W	ROBERTS.C	HUGHES.R	JONES.D	WALL.R	
MBEY.L	LAYTON.G	RUMSEY	KYNCH.H.E.V	JENKINS.S	WATKINS.G.I	
IES.A	LEE.W.L	REGAN.B	KNIGHT.A.C	KING.W	WORTHINGTON.	
IES.A	LEINTHALL.W	ROBERTS.G.R	O'GRADY.B	LEWIS.N.W	WEBB.J	
IES.E.E	LEWIS.B	RIDLEY.J	CASEY.F	LEWIS.P.T	WOODS.J	
IES.C.J	LEWIS.E.A	SAVIGAR.C.L	JAMES.J	LEWIS.F	SMITH.A.L	
IES.S.E	LEWIS.J	SAYCE.H	STANTON.J	LAKER.J	IRELAND.A.	
.H	LEWIS.T.A	SCOTT.W	TAYLOR.F.J		COLEY.G	
.S.A	LITTLE.J	SEABORNE.R.J	LYNE.W.H	LASCELLES.R.H	GIBSON.L	

28A. MARKET HALL

Next time you visit Abergavenny Market Hall pause in the entrance
foyer from Cross Street and take a look at the three war memorials
sited there. The First World War had a huge impact on our small town
and surrounding villages, as the list of 219 names inscribed on the
marble tablet testifies. Significant dates include May 1915, the Second
Battle of Ypres.

"When you go home, tell them of us and say, for your tomorrow we gave our today."

LLEN. D.N.
LLEN. L.C.
NTHONY. J.B.
AILEY. W.
ANCROFT. R.J.
AYNTON. R.C.
EARCROFT. K.R.
ENNELL. T.W.
ENNETT. A.
EVAN. E.R.
EVAN. G.A.M.
GGS. G.P.
RAIN. P.C.J.
ROOM. W.J.
RUTON. W.H.
URTENSHAW. W.H.
WATER. W.W.H.
HADWICK. I.R.
HARLES. B.H.
LEMPSON. R.J.
OLGAN. F.H.
OOK. E.N.
RUMP. J.C.
AVIES. A.W.
AVIES. A.E.
AVIES. H.J.
AVIES. H.
AVIES. I.G.J.
AVIES. I.E.C.
AVIES. J.R.
AVIES. P.G.
AVIES. V.
AVIS. E.J.
AY. S.H.
EAN.
BB

DOYLE. W.
EDWARDS. W.A.
EDWARDS. W.E.
EVANS. B.
EVANS. J.
EWERS. W.
FEAR. J.
FENCOTT. L.J.
FORTEY. H.J.
FREEMAN. F.A.
FRENCH. W.H.
GARDNER. G.A.
GAUDERN. W.H.
GIBBON. R.J.
GODFREY. F.R.
GORTON. H.
GRIFFITHS. R.
GRIFFITHS. W.J.
HALL. J.W.
HARVEY. P.C.
HASTINGS-JONES. E.G.
HEYWOOD. G.C.
HILL. W.W.
HINES. T.W.
HOLLAND. J.P.
HOLMES. D.D.
HOLMES. F.G.
HUGHES. J.T.
HYBART. G.
HYDE. J.C.H.
IBALL. W.H.
JAMES. A.J.
JAMES. F.
JAMES. S.

JONES. A.W.
JONES. F.B.P.
JONES. S.L.
KENNETT. R.G.
KILNER. R.H.
KING. W.T.
KINGSBURY. D.
KNIGHT. J.A.
LACEY. E.R.
LAMPARD. C.J.
LAWRENCE. J.
LAYCOCK. P.S.L.
LEE. D.
LEWIS. A.R.
LEWIS. D.A.I.
LEWIS. J.W.
LEWIS. N.J.
LEWIS. W.T.
LLEWELLYN. V.D.
LLOYD. C.W.V.
LOVERIDGE. A.C.
McCLACHLAN. R.
MALLARD. J.W.
MANN. P.
MATHEWS. S.H.
MATTHEWS. A.E.A.
MEREDITH. W.C.
MORGAN. A.D.
MORGAN. J.R.
MORRIS. D.W.
MORRIS. H.
MOSELEY. O.R.C.
MUHAMMAD. F.
NANCOLLAS. W.G.
NEIL. J.

OGONE. P.
OWEN. G.
OWENS. R.A.
PEACOCK. A.H.
PHILLIPS. H.
PHILLIPS. P.C.
POWELL. G.J.
POWELL. J.R.
POWELL. V.I.
POWELL. W.O.L.
PRICE. L.J.
PRICHARD. W.G.
PRITCHARD. J.H.
PROSSER. R.L.
RALPH. J.
RAMSAY. C.D.
RAWLINGS. D.P.
RAWLINS. D.D.
REYNOLDS. C.R.
RICE. W.B.
RIORDAN. T.
RUTHERFORD. E.P.
SANFORD. E.A.
SANFORD. P.A.
SAVERY. M.G.
SHEPHERDSON-CAREY. R.H.M.
SMITH. F.
STEPHENS. L.
STONE. L.
THOMAS. A.J.G.
THOMAS. E.L.J.
THOMAS. G.
THOMAS. J.G.
THURSTON. H.C.
TONKIN. W.C.

VALE. L.R
WALL. A.
WALSH. S
WANKLYN.
WARREN.
WHEELER
WHITELEY
WILLIAMS
WILLIAMS
WILLOUGH
WINNEY.
WITHERS.
WOOD. J.

CIVILIA
FAULKNEP
GARDNER
JONES. J
THOMPSC
WILLIAMS

AFGHA
HUNT. R

28B. MARKET HALL MEMORIAL

On the opposite wall is the Second World War and later conflicts' memorial. Both plaques were displayed upstairs by a staircase in the Town Hall but brought down to give them greater prominence. To the right is a smaller London & North Western Railway plaque.

29. HIGH CROSS

In the 1970s, three shops in High Cross were deemed unsafe and scaffolding was erected. Red girders then shored up the side of the building and it acquired the name 'Red Square', a nickname it still retains. The name High Cross is thought to have originated because it was at a junction, as opposed to the Low Cross junction near the Angel Hotel. *Inset*: the red girders.

30. THE ANGEL HOTEL

The Angel Hotel, a former coaching inn, was awarded the title of AA Hotel of the year, Wales 2016/17, and has won national awards for the best afternoon tea. The earliest record of the hotel was in the early eighteenth century. At one time the central entrance was a carriageway through to the inn yard, which is shown on an 1834 map. *Inset*: the hotel and Cross Street before the Town Hall was built.

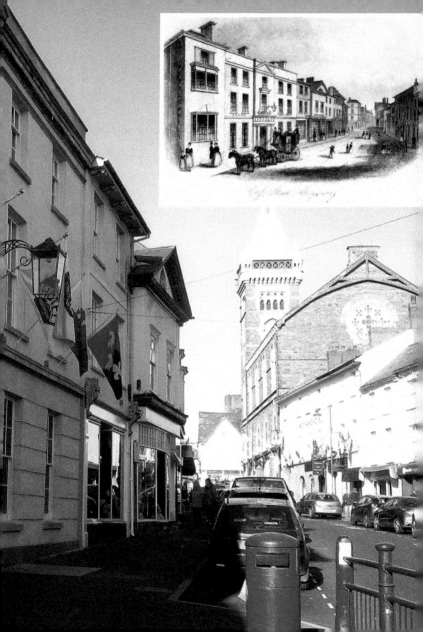

31. ST MARY'S PRIORY CHURCH

St Mary's Priory Church has been described as 'the Westminster Abbey of South Wales' and contains some superb restored monuments and sculptures. The church was founded after 1087 as a Benedictine priory by Hamelin de Ballon. It was rebuilt in the fourteenth and nineteenth centuries. In November 2017, the Lewis Chapel was dedicated to St Joseph. The dedication of the Herbert Chapel to St Benedict will be at a later date.

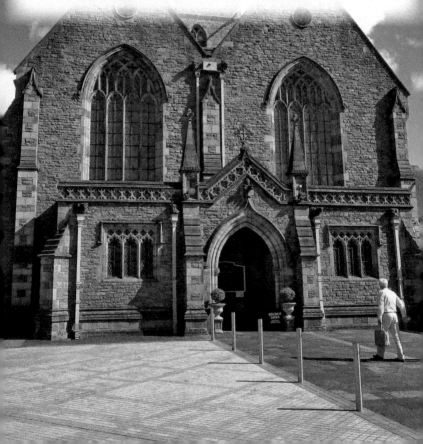

31A. JESSE TREE

One of St Mary's greatest treasures is the Jesse Tree, a fifteenth-century wooden carving detailing the lineage of Jesus Christ, which has been described by Tate Britain as one of the finest medieval sculptures in the world. In November 2017, it was moved to the Lewis Chapel of St Joseph under the new Jesse stained-glass window designed by Helen Whittaker, created in memory of the former parish priest, Revd Jeremy Winston, who died in 2011.

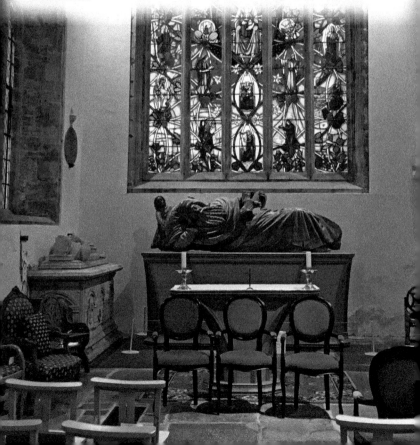

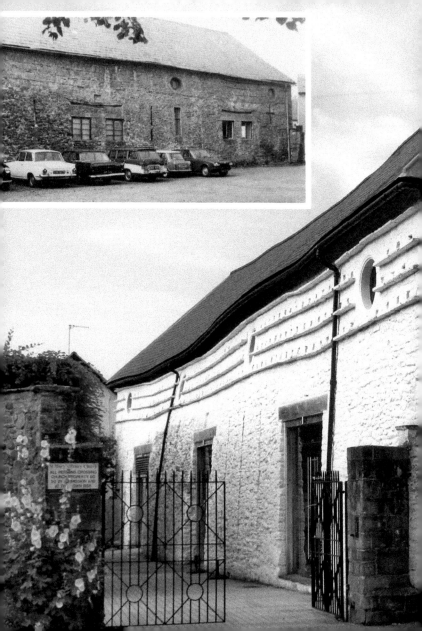

32. TITHE BARN

Alongside the priory church is the beautifully restored Tithe Barn, a mainly fourteenth-century building on a twelfth-century site. Before it was bought back in 2002 by St Mary's Priory Church, it was a seventeenth-century theatre and, more recently, a discotheque and a shop selling carpets. Now it interprets the church's history through interactive exhibitions and activities, and currently houses the tourist information centre. On display upstairs is the beautiful Abergavenny Tapestry.

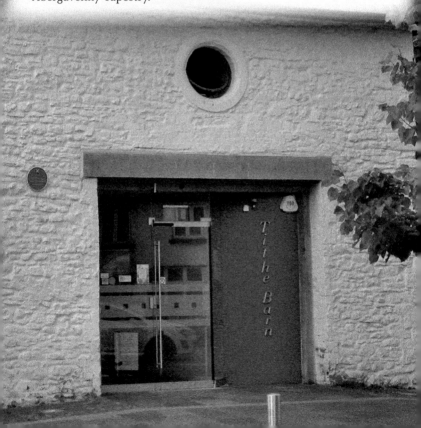

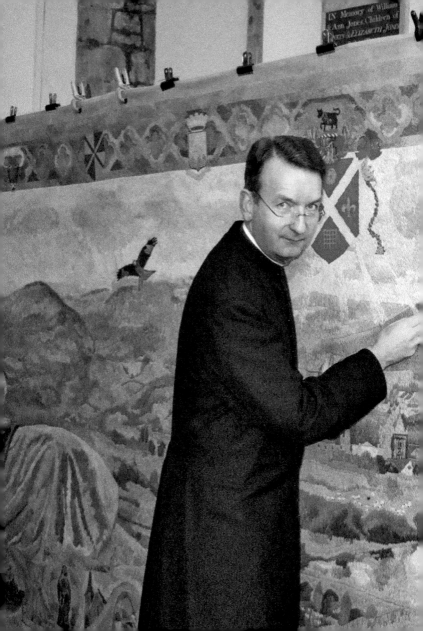

32A. ABERGAVENNY TAPESTRY

In the tithe barn, the magnificent Abergavenny Tapestry measures 24 feet by 6 feet and started as a millennium project. It celebrates a thousand years of the town's history, taking a dedicated team of sixty nearly four years to complete. More than 400 shades of wool were used. Stitchers viewed their work as 'painting with wool'. Pictured is Revd Jeremy Winston with Mrs Sheila Bevan, the inspiration behind the tapestry.

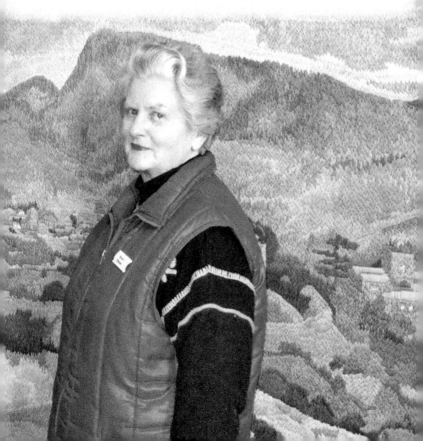

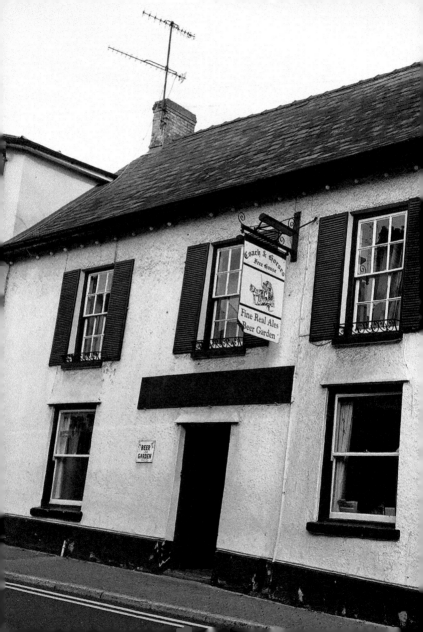

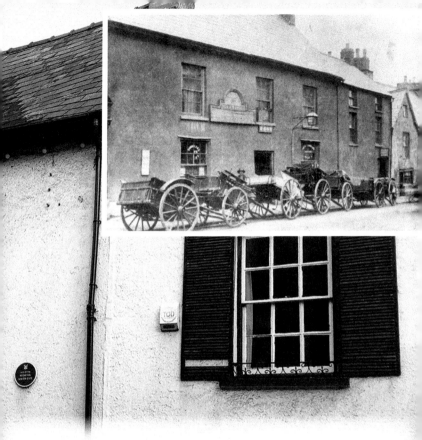

33. COACH & HORSES

A blue plaque on the front of the Coach & Horses pub marks the site of the medieval south gate in the town wall. *Inset:* the pub was previously The Sun Inn, pictured here on a market day in the 1920s. Cymreigyddion y Fenni, the Abergavenny Welsh Society, supported by Lord and Lady Llanover and Thomas Price among others, was founded here on 2 November 1833.

34. GUNTER MANSION

Gunter Mansion has been bought by the Welsh Georgian Trust and a friends' group has been formed to conduct historical research and organise 'pop-up' events while a bid is made for Heritage Lottery funding so urgent restoration work can be carried out. The house has a secret chapel where Abergavenny's own St David Lewis and other priests said Mass. He was arrested in 1679 and martyred for his beliefs.

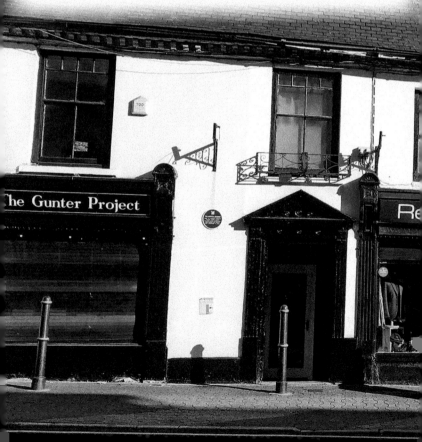

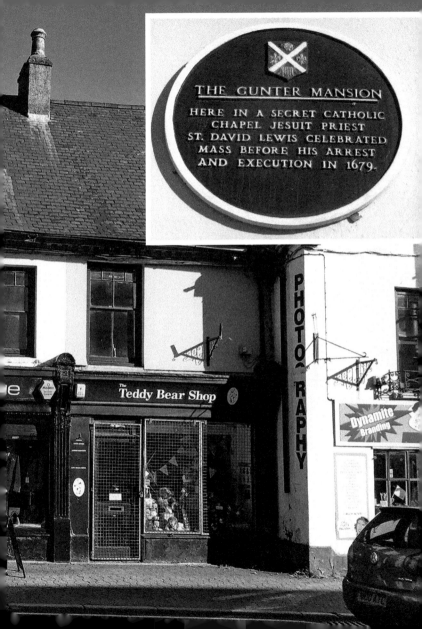

THE GUNTER MANSION

HERE IN A SECRET CATHOLIC
CHAPEL JESUIT PRIEST
ST. DAVID LEWIS CELEBRATED
MASS BEFORE HIS ARREST
AND EXECUTION IN 1679.

35. BUS STATION

Abergavenny acquired a bus station in 1931 and it was originally leased to the Red & White Co. Part of the site, the Milsteel Fabrications building, used as a bus maintenance depot until the 1980s, has been knocked down and replaced in 2017 by the Riverside Court retirement complex, seen here at the back. Today, the bus station is a popular destination for Sunday bikers – and a stopping point for Madam Marsh on the Knight Bus in *Harry Potter and the Prisoner of Azkaban*.

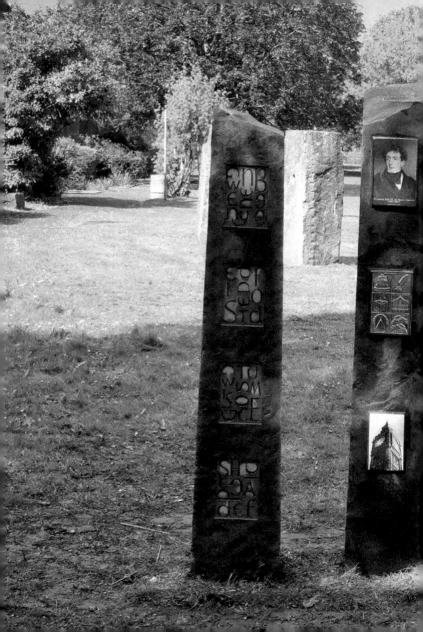

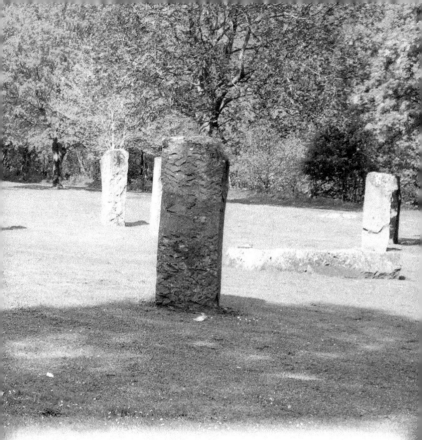

36. SWAN MEADOWS

Swan Meadows by the side of the River Gavenny is the setting for the bardic stones used in Bailey Park for the 1913 National Eisteddfod. They were at Monmouth Road before being moved in 2001. The twin standing stones next to them celebrate Abergavenny's importance in the eisteddfod tradition in Wales, and the work of Lord and Lady Llanover, among others, in promoting it. The local Abergavenny Eisteddfod was restarted in 2004.

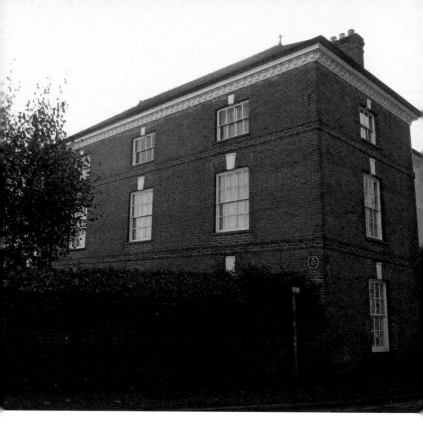

37. TAN HOUSE

The eighteenth-century Tan House is now part of the Pegasus Court
retirement complex. The house was once the master tanner's home,
and tan pits and workshops lay nearby. The leather industry was then
one of the most important industries in the town. The tannery was
situated at one end of town to keep down the smell. Behind the house
is a mill waterwheel dedicated to the residents of Mill Street.

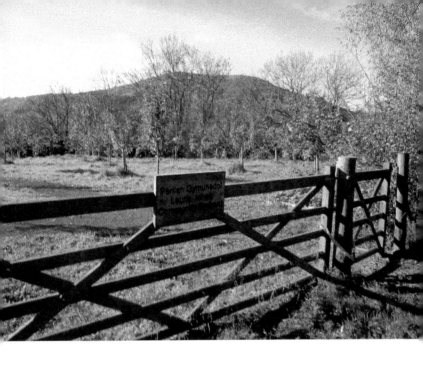

38. THE LAURIE JONES
COMMUNITY ORCHARD

The Laurie Jones Community Orchard was established in September 2011, on an acre of council-owned land at Mill Street. Ninety fruit trees have been planted with help from local schools. The group aim to establish a series of community gardens, orchards and allotment sites. They also want to enable people with more garden than they can use to meet those who want more land to garden. Another project is the Incredible Edible Abergavenny scheme with produce grown in beds around the town.

39. CASTLE MEADOWS

Castle Meadows is a stroll away from the town centre. It's where the River Gavenny – which gives the town its name – joins the River Usk, and has a medieval bridge on one side. A second pedestrian and cycle bridge is planned close by. The 20-hectare site was chosen as the main venue for the 2016 National Eisteddfod. The floodplain is a popular spot for joggers, walkers, fishermen, cyclists, families enjoying the open air or exercising their dogs, and geocaching enthusiasts.

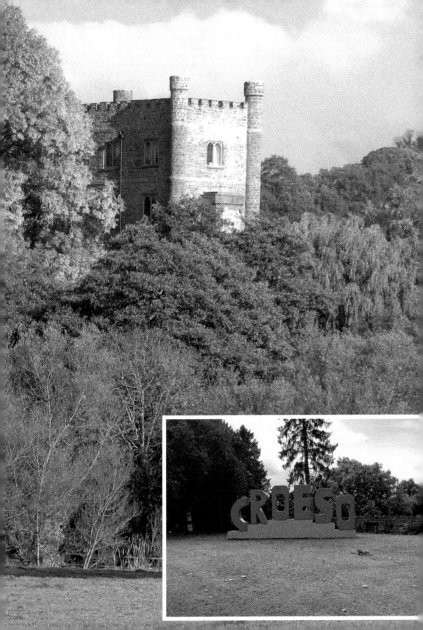

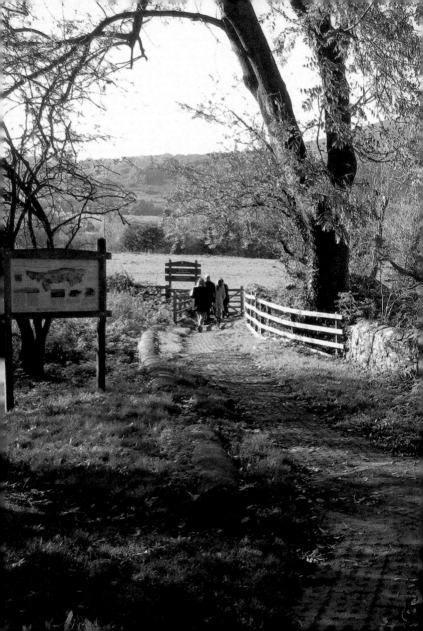

39A. CASTLE MEADOWS

A few years ago, the Castle Meadows copse below the castle was a neglected area, but is undergoing restoration. Flowers are appearing thanks to a planting programme of native species by the Friends' group. A hedge has been planted as part of the Welsh Long Forest project. A cleared bank has small native woodland trees to commemorate the Battle of the Somme. Paths have been created, and a log circle provides a place to sit, listen and contemplate.

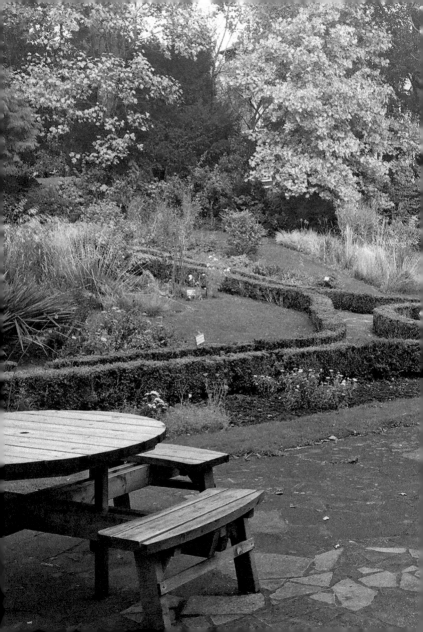

40. LINDA VISTA GARDENS

Linda Vista Gardens ('beautiful' view in Spanish), one of the lovely green spaces in Abergavenny, were once privately owned. In 1957, they were sold to the local authority to be used as a public park. The gardens include an excellent collection of rare trees and shrubs such as the Foxglove tree, an Indian Bean tree, a Judas tree, a Gingko, and an enormous and old London Plane. The Friends' group has planted an autumn-colour tree collection. *Inset*: a sculpture depicting Abergavenny history.

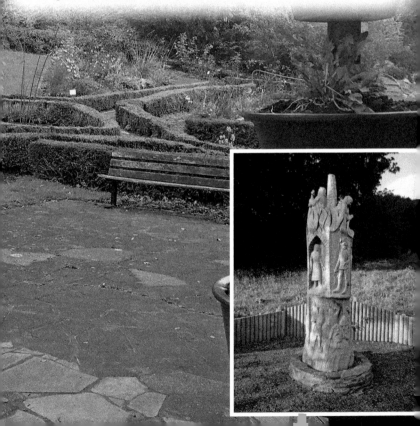

ABOUT THE AUTHOR

Irena Morgan is a retired journalist who worked on local newspapers throughout South Wales, and was then in charge of the press and publicity campaign for a project to honour the work of Aneurin Bevan and the Tredegar Medical Aid Society for the 60th anniversary of the NHS. She has a keen interest in local history, and is an honorary member of Abergavenny Local History Society. During her time as the society's chair, she brought to completion the society's DVD, *The Abergavenny Story*.

She led the project to create six children's plaques in the town centre, and the associated twin standing stones Eisteddfod tribute in Swan Meadows. This led to a project in 2009 to commemorate the 150th anniversary of 'Big Ben', the great bell in the Elizabeth Tower at the Houses of Parliament, and the role of Lord Llanover, Benjamin Hall. Llanover schoolchildren designed a plaque that hangs in the tower's museum.

She has previously written the books *Abergavenny Past and Present* and *Abergavenny Through Time*. She has been presented with the Gwent Local History Council Award for her work.

She belongs to the Friends of Castle Meadows, one of three 'Green Flag' award-winning open spaces close to the town centre, all worthy of a longer exploration. The others are Bailey Park and the Laurie Jones Community Orchard.